▲ *Abbey and parish Church with the monastery from the southeast*

History

With its striking western façade, the Romanesque St. Eucharius-St. Matthias Basilica dominates the district of the same name at the southern edge of the ancient Roman city of Trier. Its location, far beyond the borders of the city center, is due to the history of the grounds on which the monastery was founded: About 25 hectares of ancient burial land lie beneath the church, monastery, and surrounding neighborhood. The Romans generally buried their dead outside of the city walls, usually along the arterial roads. The southern burial site of Trier lies on the road leading to Metz. The foundations of the late-second-century "Porta Media", the southern gate of the ancient city wall, were discovered near the church. The necropolis contains a total of 4000 – 5000 stone sarcophagi, portions of which are buried in four to six layers on top of one another. It was constantly in use from the end of the first century BCE. Beginning in the middle of the third century CE, it developed into one of the oldest Christian cemeteries

north of the Alps. Recent excavations west of the crossing of the Romanesque church revealed densely tiered rows of inhumation graves. Coin offerings at the lowest level indicate origins around 270/80 CE, and the upper level exhibits a burial tradition dating into the seventh century. Between the graves, remains of about thirty sepulchral buildings were found. Some of these vaults were known as early as the sixteenth century as "crypts at St. Matthias" (with prior reservation, three crypts can be viewed). The most important, the so-called "Albana crypt" (fig. p. 41), lies beneath the Quirinus Chapel. It was presumably part of a Roman estate that, according to a tenth-century legend, belonged to the widow *Albana*. In the second half of the third century, St. Eucharius, the founding bishop of the diocese of Trier, is said to have taken refuge here and erected a church dedicated to John the Evangelist. However, neither the patronage nor the exact location of the church has been verified.

Around 450/55, *Bishop Cyril* renovated the "cella S. Eucharii", which had been abandoned after the Frankish wars. Beside it, he erected a larger church, into which the remains of his predecessors were transferred. It is probable that a "monasterium" was already established at that time, not a monastery in the modern sense, but a community of clergy to supervise the burial place.

In 882, the Cyrillus church was destroyed during a Norman assault. *Archbishop Egbert* began a new building. It was also Egbert, together with his predecessor *Theoderich I*, who introduced the Rule of St. Benedict as the basis of monastic life around the year 977 and convened monks from Ghent's St. Bavo in Trier. At the beginning of the twelfth century, the abbey came under the influence of a monastic reform movement named for the Benedictine abbey of Hirsau, in the Black Forest. Another flourishing period is recorded between 1420 and 1440, under the reforming *Abbot Johannes II Rode*. No later than 1458, the convent of St. Matthias joined the Bursfelder congregation, another reform movement that originated in the Bursfelde/Weser monastery. The building of the current church, the third structure to be erected on this location, is connected with another aspect of the history of St. Eucharius-St. Matthias: the pilgrimage to the grave of the

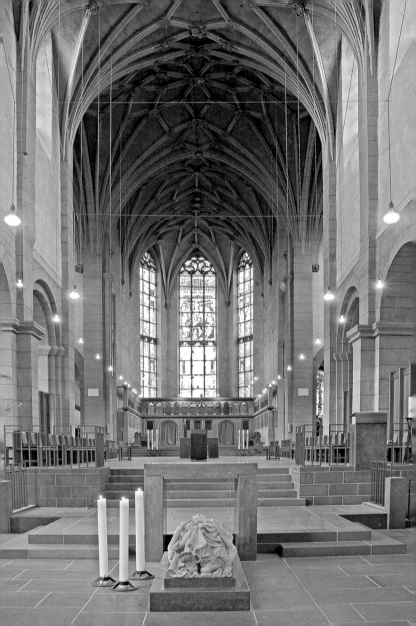

▲ *Pilgrimage shield*
(only on exhibit for the pilgrimage)

apostle Matthias. In 1127, shortly after construction began, the ark with the apostle's remains was discovered. These had been in the old Marian altar of the previous building. According to legend, *Empress Helena* sent out *Bishop Agricius* in the first third of the fourth century, and among his assignments was to transfer of the relics of Christ's disciple to Trier. The repository of remains near the graves of the first bishops was apparently forgotten during the Middle Ages. After its rediscovery, a pilgrimage quickly developed to this, the only apostle grave north of the Alps. Its significance is evidenced by the fact that the feast day of the original patron, St. Eucharius, on December 9th, was supplanted over time by the feast of patron St. Matthias on February 24th.

The church and monastery experienced eventful periods after the Middle Ages, as well. In contrast to the three other medieval Benedictine monasteries of Trier, St. Matthias survived the wars of the seventeenth century relatively unharmed, primarily due to its location about two kilometers beyond the medieval city walls. The monastery was secularized in 1802, and the church came into the estate of the newly founded parish of St. Matthias. In 1803, *Christoph Philipp von Nell* purchased the cloister buildings, gardens, farmland, and vineyards at auction. The abbey was used as an agricultural estate and manor house from that point on.

Beginning in 1880, the monastery was resettled by Benedictine monks from the Beuron congregation. However, it was not until 1922 that monks from the Seckau Abbey in Austria and from the Maria Laach Abbey could once again festively process into St. Matthias. After the temporary expulsion of the monks between 1941 and 1945, the monastery and parish have become an established element of church life in Trier today.

Architectural History

To the west of the Quirinus Chapel, buried remains of the foundations of a single-aisled roofed hall with a half-circular apse were discovered. These were connected by a staircase to the Albana Crypt, which lay beneath the eastern section. Whether these are the remains of the legendary church of St. Eucharius cannot be established.

The **Cyrillus building** from the mid-fifth century was presumably the first sacred structure to be built on the site of the current church. However, no remains of the burial and memorial structure were found recently beneath the Egbert Crypt, so that its hypothetical location south of the current crossing has been cast into doubt. It is also unclear whether it was intended to be a central-plan structure or a single-aisled roofed hall. The **dedicatory inscription** and an **altar or choir screen** [12] are among the remaining furnishings that were reconstructed in the existing crypt using original stone slabs.

The second church was begun by *Archbishop Egbert* in the last quarter of the tenth century – probably around 980/990 – and was completed under *Abbot Bertulf I* in the first half of the eleventh century. The new building was also connected with the renovation of the monastery. Across from the eastern choir with the crypt, the western side of the three-aisled **basilica** held a three-sided split apse, framed by round stair turrets. The double-choir arrangement gained previously unknown significance in architecture of the eleventh century. The western apse between towers recalls other western sides of churches of the same period, such as the Trier cathedral, the first cathedral of Worms, or the Münster of Essen. Only the three former eastern nave bays of the three-aisled **crypt** [12] still remain. Today, they serve as west bays of the crypt, which was expanded towards the east until about 1510. Their groin vaults rest upon four columns with Attic bases, which indicate origins in the tenth/eleventh century. Of particular interest are the shafts of the easternmost pairs of columns, which originally stood in the altar area: They are made of two-thirds green marble and are apparently of Roman origin. The crypt originally had six bays; the three western bays were leveled in 1848 and dug up in 2004/05. Remains of

the first stairway, which led to the crypt from the west, also came to light. In addition to the stair foundations, remains of the side walls were also preserved. Of particular interest here are the beginnings of two window-like openings, whose arcades were inset on each side. These illuminated the stairwell through light shafts on the sides (fig. p. 9).

The **Romanesque abbey church** was begun in the east under *Abbot Eberhard I von Kamp*. The older crypt was retained, so that the dimensions of the new choir were predetermined. It was long presumed that the front wall of the new southern transept arm also belonged to the Egbert building. However, this theory has been called into question, since its connection to the crypt has not been verified. Construction apparently progressed rapidly. Parts of the choir must have already stood as tall as the arch in 1127, when scaffolds were installed to board a crossing arch, at which point the old Marian altar was destroyed and the relics of the apostle Matthias found. This assumption is confirmed by a fire in 1131: At that time, fire broke out in the sacristy at the northern side of the choir, affecting the practically completed choir as well as the transept, which was still under construction. In light of the site's size, it seems likely that construction began in the second decade of the twelfth century, contrary to previous conjecture.

The fire damage was repaired shortly after 1131, and the choir and transept were practically completed. Whether the erection of the main choir was connected with the discovery of the St. Matthias relics cannot be determined with certainty. This recently repeated theory is contested by the fact that the older crypt was incorporated into the newer building from the beginning – before the discovery of the relics and before the fire. The nave was begun simultaneously with the completion of the eastern section. Earlier excavations revealed a joint in the foundations of the northern aisle wall by the fifth eastern arcade pillar. This discovery supports the assumption that at least the lower sections of the five eastern bays of the aisles were already standing in 1131. Soon after 1131, the eastern section of the nave was completed. The chronology of the construction can be construed in part from the fact that the transept and nave are not linked over the vaults, so that the

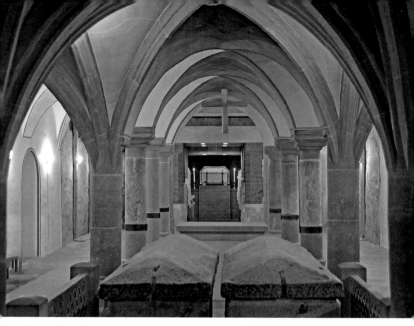

▲ *View from the east into the crypt, with the shrine of the apostle Matthias and the sarcophagi of bishops Eucharius and Valerius*

walls in the upper area must have been erected at different times. The lower floors of the western building up to the cornice were built at the same time, probably to bear the thrust of the nave. The second phase of construction was finished around 1148.

On January 13, 1148, the church and seven altars were consecrated by *Pope Eugene III* and Trier's *Archbishop Albero*. The **dedication cross [9]** in the southern aisle bears witness to the occasion. The more recent forms, particularly at the western end of the building, suggest that the church was not fully completed at the time of its dedication. Accordingly, the gap in the nave was closed after 1148, extending the nave wall up to the cornice and covering the nave with a groin vault. The trapeze-shaped story of the western side of the building and the western tower were constructed at the same time. The final phase of

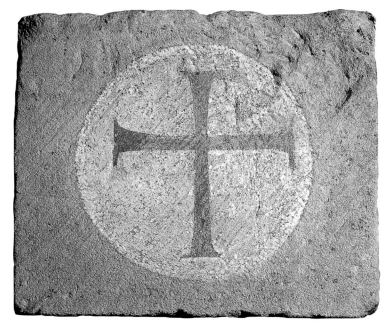

▲ *Dedication cross, c. 1148*

construction also included the window story in the northern choir tower. The abbey church was finally completed around 1160 under *Abbot Bertulf II*.

The result was a Romanesque basilica with a tower façade, transept, and choir flanked with towers in which side choirs were integrated. The nave was arranged with a "bound system", meaning that for each of the four square bays of the central aisle, there were two corresponding square bays in the side aisles. The basis square was established in the crossing, the central part of the structure, where the nave and transept cross. The nave walls formed a clearstory above the arcade zones, with two round arched windows arranged in pairs towards the center.

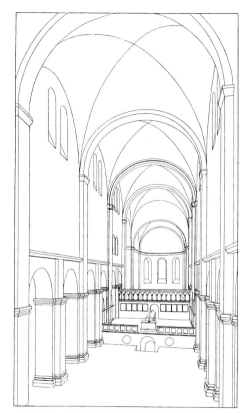

▲ *Reconstruction of the Romanesque interior with choir screens (drawing by N. Irsch, 1927)*

Vertical elements before the walls above every second pillar appeared to carry the transverse arch of the groin vault.

The arrangement of towers flanking the choir has been compared with buildings of the so-called Hirsau school of architecture. This group's solution for the choir was based on monastic-liturgical reforms from the monastery of the same name, which had joined the

St. Matthias Abbey under *Abbots Eberwin* and *Eberhard I*, the first builder of the church. The design of the eastern sections, however, also followed construction customs from the Trier region. Subsequent structures, for example the eastern choir of the cathedral of Trier, or the choir of the collegiate church in Karden, also have choirs flanked by towers. The St. Matthias basilica is thus well embedded in the architectural development of the Trier region in the twelfth century and holds an important position within that tradition. This is particularly true of the nave, which was one of the first to be vaulted from the beginning. Influences from the Lorraine in the later western sections also testify to the affiliation with this artistic circle.

After construction was completed, the St. Matthias Church was redesigned and expanded several times. In the first half of the thirteenth century, two double windows were inserted into the first and fifth bays of the southern side of the nave, in the fashion of a prayer loge. They offer a view of the apostle's grave and the main entrance, and are probably connected with the construction of the adjoining cloister. The **portal to the cloister** [18] in the southern transept arm and the **choir screens** [24] were created during the same period.

The renovations that were executed under *Abbot Antonius Lewen* were decisive in shaping the church as it appears today. These interventions changed the basilica considerably and became a significant example of Late Gothic architecture in the city of Trier: Between 1496 and 1504, the nave and transept were adorned with a Late Gothic reticulated, or stellar vault (fig. p. 29). The work was led by a stonemason from Trier named *Bernhard*. After his death, *Meister Jodocus*, a mason from Wittlich, oversaw construction of the apse and the vaulting of the choir until 1510. The Romanesque round arch windows in the nave and transept were replaced by Late Gothic tracery windows. Today, only the two extended windows of the transept façades retain their restored mouchette tracery. In order to visually integrate the stellar vaults, vertical elements in front of the walls were raised above all of the pillars. The ribs extend from the elements without imposts. The previous closing end of the choir was replaced by a larger Late Gothic apse with three-sided closure and extended windows with mouchette

▲ *View from the east*

tracery. Three new bays were added to the crypt of the Egbert build-ing, extended it towards the east, and it was vaulted over. In the pro-cess, the sarcophagi of the canonized bishops Eucharius and Valerius were exposed. These still stand in the crypt today (fig. p. 9).

Lewen's building projects also included the installation of a reliquary chapel, the **Chapel of the Cross** [22], in the northern choir-flanking tower, as well as the eastern section of the Romanesque sacristy, in 1513. Relics and other precious objects were kept in the treasure chamber. The richly profiled, arched doorway to the courtyard on the northern wall of the upper floor is now walled up. It is linked to the function of the chapel and the sacred area at the north side of the church: It belongs to an exterior pulpit, of which only fragments remain. From here, the faithful and pilgrims were shown the relics, which could be worshipped within, through a viewing window orna-mented with tracery in the northern side-choir.

Further changes only followed in the seventeenth and eighteenth centuries, primarily on the western façade. The projects began in the third quarter of the seventeenth century. Under *Abbot Martin Feiden*, rows of volutes were added on the sides of the trapeze-shaped upper floor of the western façade, and volute pediments were built in front of the lateral saddle roofs of the northern and southern sides. In 1689/92, under *Abbot Cyrillus Kersch*, the baroque **main portal** [1] was created. *Abbot Wilhelm Henn* added the two **side portals** [3] and the **exterior portals** [4] to the cemetery and cloister in 1718/19. Under *Abbot Modestus Manheim* and his successor *Adalbert Wiltz*, works on the church interior were recorded: In 1748, the medieval main choir was given up. The old western entrance to the crypt was replaced by two side entrances in the crossing, and the choir was set off from the nave with a curved marble staircase and a baroque communion rail. Stuccowork and paint were applied to the groin vaults of the side aisles. It may be that the baroque windows in the side aisles date to the period around 1768, when the tracery of the clearstory windows was removed.

On September 8/9, 1783, a heavy fire broke out in the sexton's quarters at the northern side aisle, particularly damaging the roofs, spire, and belfry of the western tower. The repairs in 1786 followed a design by *Johann Anton Neurohr*. The western tower was reconstructed in sandstone, beginning at the pedestal frieze. From a contemporary perspective, the sense of historical preservation is notable: Old pieces of work were saved and reused, new ornamental pieces largely conformed to Romanesque models. The baroque classicist crown was added, with its balustrade, vases, and clock-faces, contributing to the striking silhouette of the famous western façade.

The interventions of the nineteenth century were primarily due to the building's new function as parish church. In 1848, the congregation space was expanded, while the high altar in the apse was displaced, and the apostle's grave relocated in front of the altar. The St. Matthias altar stood as a new main altar in the crossing, so that the marble stairway could be moved into the second bay in front of the crossing. The western half of the crypt was given up.

Crucifixion window in the apse ▶

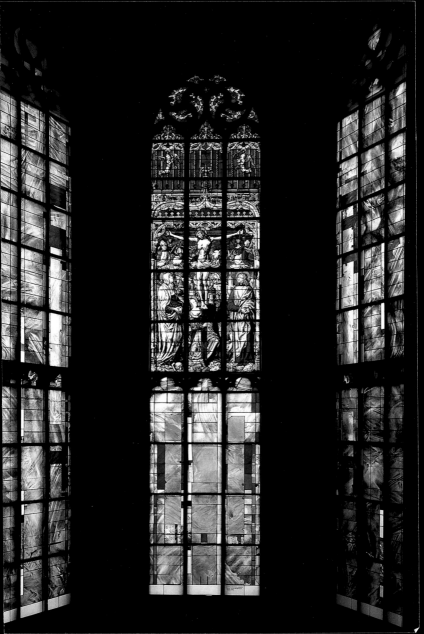

Three large restorations were implemented in the twentieth century. *Edmund Renard*, province conservationist for historical preservation in the Rhine region, led the first comprehensive restorative undertaking between 1914 and 1921. The coloring of the interior was virtually re-designed, including tendril patterns in the vaults, based on traces of the old painting. Between 1958 and 1967, the structural soundness of the existing architecture and the repair of structural damage were supervised by the Aachen architect *Willi Weyres*. In addition, the interior was painted and the liturgy was newly organized according to the decisions of the Second Vatican Council. The goal of the third restoration, between 1985 and 1992, was to reestablish the exterior color scheme. This project was overseen by *Karl Peter Böhr*, from Trier. The exterior renovation of the buildings around the open courtyard followed until 1995. Until 1998, the square in front of the church was reconstructed, including a new fountain (fig. p. 22/23). *Franz Johannes Moog*, from Mayen, provided the design for the fountain and for the water spout. The fountain's cross was created by Trier sculptor *Willi Hahn*, in 1957. Finally, in 2000, *Christoph Anders*, from Senheim, sculpted the relief, "Christ, Peter, and Eucharius" above the courtyard portal.

Between 2004 and 2007, the area around the crossing was re-structured under the leadership of *Karl Peter Böhr* and *Karl Feils*, from Trier: There is now a modern block altar in the second bay west of the crossing, directly above the tomb of St. Matthias in the crypt. The Late Gothic figure of the apostle in front of the altar also indicates the grave, and a small window embedded in the floor beneath the altar offers a view of the sarcophagus. A new stairway at the side of the altar leads into the crypt. The entrances that were transferred from the crossing into the side aisles in 1927 now provide access for disabled people. Behind the now open altar area, for which the curved baroque steps and communion rail were removed, the monks' choir is now located in its traditional place in front of the crossing. After the crossing, with the modern granite high altar, consecrated in 2008, the baptismal area with baptismal font was installed in the main choir. At the same time, in the crypt, the western bay of the former Egbert crypt was unearthed, exposing its original entranceway (fig. p. 11). The remains of the

▲ *Courtyard portal with relief of Christ, St. Peter, and St. Eucharius*

unusual stairway were redesigned in a three-aisled apse-like arrangement, and the stone sarcophagus with the apostle's remains was positioned at its western end. The damaged bay between the former entrance and the three surviving bays of the early medieval crypt was enclosed with a flat concrete ceiling borne by concrete columns (fig. p. 9).

Architectural description

The St. Matthias Church is a three-aisled pillared basilica whose floor-plan is based on the form of a cross. It is approximately 75 meters long and 22 meters wide.

The Exterior

Partially reconstructed in 1786, the three-story **western façade** with its two-story central tower is the face of the church that is visible from miles around. Pilaster strips divide the two lower floors into three vertical courses, of which the central one is wider than the sides. The side areas are subdivided by narrow central pilaster strips. In the middle section of the facade, a **Romanesque stepped portal** [2] with inset columns opens onto the ground level. Today, it is covered by the **baroque main portal** [1]. A round arched window group and a round window are embedded in the wall above. There were originally no portals in the side area. The various structuring elements suggest that a double-tower façade was initially planned.

After a change in plans, a new architect designed the third story and the lateral rectangular central tower. Three connected blind arches with lavish leaf ornamentation decorate the wide central section of the façade's middle story. The side gables are stepped and also bear leafage. Around the middle of the seventeenth century, volutes with vases and pinecones, among other motifs, were added. The side saddle roofs were also embellished with volute gables with niches for the figures of St. Eucharius and St. Valerius. The concluding element of the façade at the top is a cornice with rich foliage ornamentation that appears today in a different color. The two open stories of the tower are broken up into bell arcades, with four on each of the broad sides and two on each of the narrower sides. Rich Romanesque-style leafage adorns the double windows. Since 1786, *Neurohr's* baroque classicist crown has risen from the top of the tower. It bears a balustrade, vases, and clock faces in half-circular frames. Although the tower was transformed by Neurohr's reconstruction, the wall's sculptural design, together with its practically exuberant ornamentation,

Southern side, view from the cloister ▶

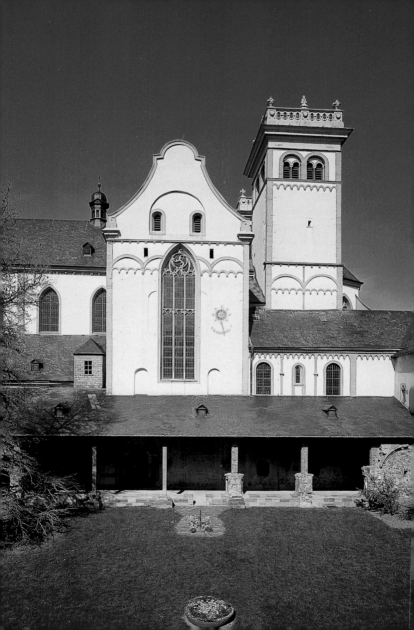

remains typical of the Trier-Lorraine school of the second half of the twelfth century.

Visitors enter the church space through the baroque portal. The original two-story **central portal** [1] from 1689 owes its design to the classical French high baroque. Columns support cornices with triangular gables. Niches with figures are embedded at the sides of the main entrance: At the left is a sculpture of St. Benedict, and at the right, St. Scholastica. Above, a sculpture of St. Matthias in a sideways motion stands in a niche with spiral columns. Two other apostles follow at the outer ends: Andrew at the left, John at the right. The sculptures were attributed to the *Master of the Madonna of St. Maximin (Johann Matthäus Müller?)*. In 1692, a second projection was built in a contrasting style to the structure below it. The columns, which are partly on consoles with ornamental foliage, support a broken pediment. In the central niche, the Mother of God stands with the infant Jesus, accompanied by angels at the sides. The arrangement culminates in the dynamic figure of the archangel Michael. The sculptures are probably the work of *Wolfgang Stuppeler*, to whom payments were recorded in 1693/94.

The lower **side portals** [3] conform stylistically to the older central portal, although they are considerably shallower. The projections with broken pediments and the coat of arms of *Abbot Wilhelm Henn* above the oval *occuli* are the only contrasting elements. *Christus Salvator* is depicted in the crowning niche of the left portal, from 1719. Sculptures of the bishops Eucharius, Valerius and Maternus are standing by the **portal to the cemetery** [4]. In the projection on the right side portal, from 1718, the worshipping Mother of God (*Immaculata*) is flanked by angels making music. Two pilgrims with staffs are positioned on the next portal towards the outside, with Christ in the center.

The **exterior of the nave** remained without structuring elements, except for flat pilaster strips after ever second clearstory window. The side-aisle windows were expanded in the eighteenth century, and the tracery of the Late Gothic clearstory window was removed in 1768. In this way, the interior was brightly lit according to the baroque spatial concept. The roof, which also had to be renewed after the fire of 1783,

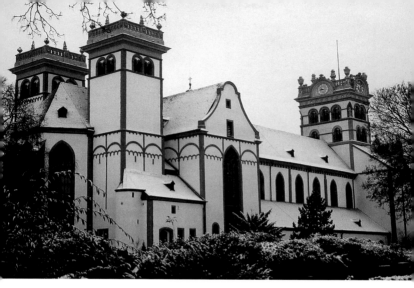

▲ *Northern side, view from the cemetery*

bears a ridge turret west of the crossing. Its position directly above the grave of St. Matthias indicates the pilgrimage destination in the church's interior.

High, three-paneled tracery windows were installed in the **front walls of the transept** at the beginning of the sixteenth century. Nevertheless, the Romanesque wall structure is still visible. The surfaces of the walls are framed by corner pilaster strips, on the southern side by corner stonework. Two rows of windows are arranged, one above the other: On the northern façade, three round arch windows were set in below, of which the outer two have survived. Two windows above, which were later faced, are closer to the center than the windows above (fig. p. 19). Above the windows, the walls are structured with a system of remarkably slender pilaster strips, round arch friezes, and enclosing arches. Here, too, there are perceptible differences between the northern and southern sides. The inconsistencies continue onto the side walls of the transept arms. The structuring arches of the

Page 22/23: Abbey and parish church with cloister,
Quirinus Chapel, and courtyard, aerial view **21**

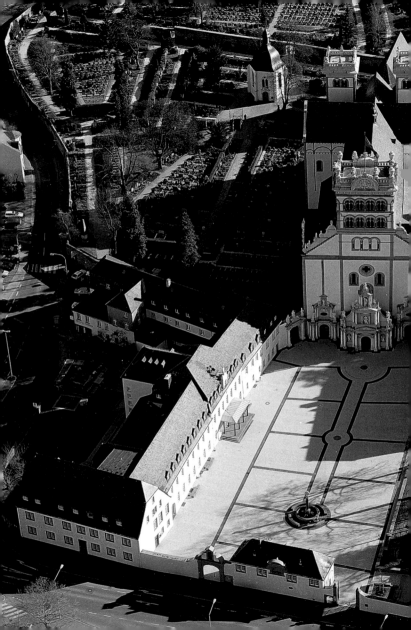

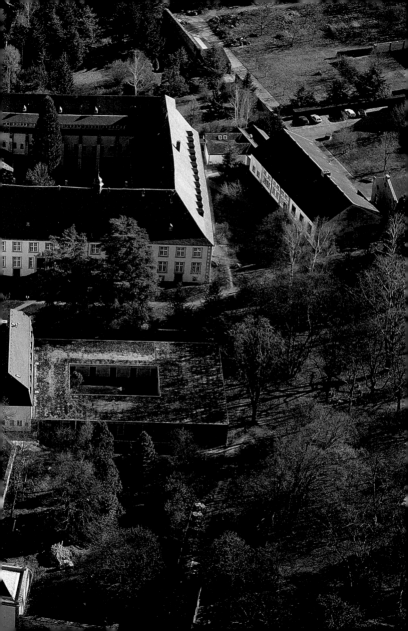

western wall of the northern arm are not equally broad, so that the outer section is considerably narrower. As a result, the windows are not on the central axis of the surfaces. One can only conclude from these variations that the pilaster strips, arch friezes, and enclosing arches were not originally planned and were only added after 1131. Reports from 1131 support this assumption, indicating that the transept was already well developed. This perspective casts doubt on the previous assumption that at least the lower parts of the walls belonged to the Egbert building.

Volute pediments topped with round arches adorn the cornice. The stylized shape and the profiled cornice, which corresponds to that of the nave, suggest that they were reconstructed with the roof in 1786/88.

The **eastern sections** are comprised of the square of the choir, the choir-flanking towers, and the polygonal apse. To the north, between the transept and towers, lies the Romanesque **sacristy** with the reliquary chapel from 1513. The building to the south, which probably dates from the first half of the twelfth century, closes the gap between the cloister and the eastern choir.

The **towers that flank the choir** stand removed from the transept. Their lower floors ends at the lean-to roof at each side of the building in thin pilaster strips, arch frieze, and two enclosing arches, so that the decorative system of the transept is continued at the same height. The next story remained without ornament on both towers. The lower bell-story above bears two bell arcades with double windows on each side. A balustrade with vases was added to the projecting cornice in 1786.

The Late Gothic **apse** is built with square-hewn stone masonry, and its compartments are divided by stepped buttresses. The red-framed lancet windows have three sections and are horizontally divided by tracery ribs. As in the transept, the mouchette tracery revolves into a pointed arch at the top.

The Interior

In the interior, the central section of the western side of the building opens to the **nave** in its full height, so that an additional, optically

Nave towards the west ▶

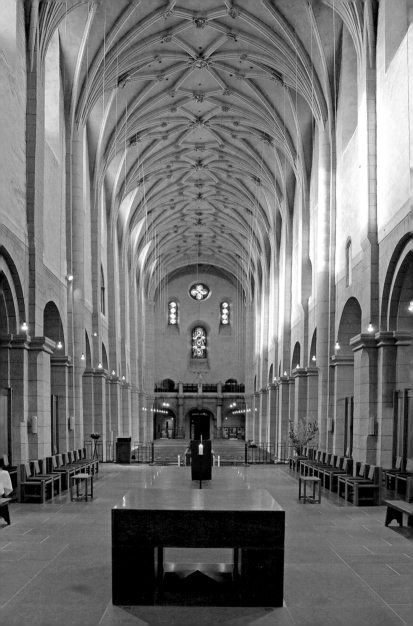

separate nave bay is actually created. The reticulated vault was retracted with the vault of the nave at the end of the fifteenth century. The reliefs on the **capstones** depict symbols and people, including the hand of God, St. Matthias, and Mary. In 1699, Abbot Cyrillus Kersch erected the **western gallery** [5] in Renaissance form with Gothicizing ribbed vaults. The bases and imposts of the nave's pillars have Attic profiles. Following the Late Gothic renovations, flat vertical elements in front of the walls rise from each pillar today. The only exception is at the second pair of pillars from the east, with half-circular wall elements and lions' heads at the bases. This may be a remnant of an earlier plan for the nave, which was not pursued further during the course of the twelfth century. Over the Gothic prayer galleries in the south and the remains of a Romanesque prayer gallery in the northern wall, pointed arch windows replace the round arch windows in the clearstory. A door that is now walled-up in the northern wall gave access to a swallow's nest organ that once stood here. The vault is constructed in the form of eight large stars, whose capstones bear reliefs. In the center are depictions of saints who are particularly significant to the St. Matthias Abbey: Among them are St. Eucharius, St. Matthias, who is shown with the kneeling founder, *Antonius Lewen*, St. Valerius, St. Maternus, and St. Agricius. Angels between the stars bear shields. Those of the two easternmost angels show the coats of arms of *Adelheid von Besslich* and of the two archbishops *Johann II* and *Jakob II* from the house of the *margraves of Baden*. The monastic church renovation took place under both clerics, and *Johann* was particularly devoted to the monastery. The coats of arms of the figures mentioned probably indicate their financial support of the construction. Symbols of the Passion of Christ follow, the "arma Christi". Reliefs of the twelve apostles and the four church fathers are applied above the windows.

The Romanesque groin vaults in the **side aisles** are supported by pilasters with Attic bases and imposts. In the eighteenth century, the groins were decorated with plaster stucco and round paintings of the apostles.

The unadorned **transept** is illuminated through the Late Gothic windows in the front wall. The **Romanesque impost capitals** in the

▲ *Imposts in the northern side aisle*

crossing and the northern side aisle [**13**] are covered with leafage and depictions of figures, in contrast to those of the nave. The capstones of the vaults also exhibit figural depictions: God the Father is shown enthroned, with his right hand raised and the Lamb before Him. He is surrounded by the choir of angels and the fourteen elders (fig. p. 29). In the northern arm of the transept, the fathers of the tribes of Israel and the prophets are represented, including King David and John the Baptist. In the southern transept arm, four female and male martyrs frame the Madonna with Child. Images of the head of John the Baptist and the archangel Michael follow to the sides.

From the transept, barrel vaulted connecting rooms lead to the straight-ended **side apses** of the choir-flanking towers. While the original groin vault of the southern side-choir chapel stands intact in its full height, Late Gothic renovations divided the northern side into two spaces, one above the other: a low barrel vaulted space on the ground floor, and the **Chapel of the Cross** [**22**] above.

In contrast to the nave, the **choir** remained free of sculptural articulation. In the stellar vaults, there are, once again, capstones with saints related to Matthias. At the end of the chancel, Christ as *Salvator Mundi* is framed by the apostle Phillip and John the Evangelist. The vault rests on consoles with sculpted evangelists' symbols and church fathers.

The three-aisled **crypt** [**12**] is divided into four sections: In the west, the shrine with the encased relics of the apostle is displayed in a flat-topped, apse-like case with modern, square supports. After a modern concrete connecting bay, three surviving bays stand erect from the crypt of *Archbishop Egbert*. The four bays of the eastern section, together with their polygonal apse, were built around 1510 under *Abbot Antonius Lewen*. Aside from the reworked flat capitals, the wall articulation of the shortened Early Romanesque crypt remains unaltered. The Late Gothic bays are oblong, the cross-ribbed vaults rest on round supports with high channeled bases.

Furnishing

As compared with earlier inventories, the furnishing today is reduced. The stained glass of the **central choir windows** [**25**], created by the St. Matthias priest-monk *Wilhem von Münstereifel*, together with the Cologne glass painter *Leo*, is the only Late Gothic glasswork remaining (fig. p. 15). It depicts the crucifixion of Christ. Angels floating beneath the crossbeam collect his blood in chalices. Mary and John the Evangelist stand to the left and right, while Mary Magdalene kneels at Christ's feet. The image, in the style of stained glass from Cologne, is one of the most important stained glass works in the Trier region. The mixture of Late Gothic ornaments with Renaissance forms is typical. Thus, traditional Late Gothic figures, such as those of Christ, Mary, and John, stand beside the image of Mary Magdalene, clad in opulent contemporary dress. The patrons of the abbey were originally depicted beside the crucifixion. The colors and subject matter of the new windows, made in 1994/95 according to a design by *Günter Grohs*, Wernigerode, are oriented towards late medieval stained glass painting.

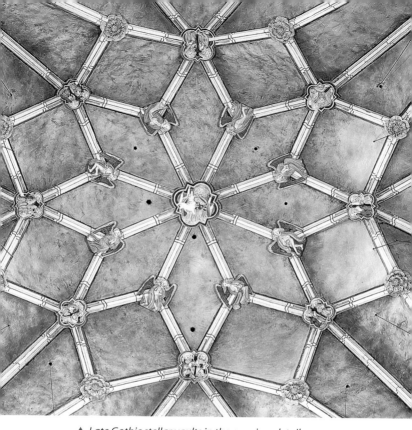

▲ *Late Gothic stellar vaults in the crossing, detail*

The Late Romanesque **choir screen** [**24**] was moved to the apse in the 1960s. The resulting construction has three wings, so that today, each of the original round arch portals on the sides opens towards the east. The screen, dated around 1230, enclosed the monk's choir on the sides, separating it from the transept wings and side aisles. Around its base are vertical rectangular coffers with black slate slabs in profiled frames. In the open arcades above, small black columns bear sculpted capitals and trefoil arches. The spandrels and the closing frieze

are decorated with plant images and palmettes. Stylistically, the St. Matthias screen is comparable to the eastern choir screen of the Trier Cathedral.

The furnishings of the high choir also include large-format **baroque paintings** [23] above the passageways to the side choirs. These depict the death of St. Benedict and of his sister, St. Scholastica. The St. Matthias altar is raised two steps above the nave. The **monument of St. Matthias** [11] stands in front of it, with a stone recumbent statue of the apostle, which dates from around 1480. In the first bay west of the crossing, the new monks' choir is raised by five steps. The choir stalls were designed by *Franz Bernard Weißhaar*, Munich.

The glazing of the large **transept windows** in the 1950s followed designs by *Reinhard Heß*, Trier. There are three **reliefs from a St. Matthias altar** [14] embedded in the northern transept arm, bearing the monogram HTB and the year 1563, apparently indicating the work of the sculptor (German, "Bildhauer") *Hans*, from Trier. The sandstone slabs show scenes from the life of Matthias. At the same location, there is also a **relief** [17] representing the martyrdom of the canonized Pope Stephanus III. The subject matter suggests that this was the main image of a former baroque high altar, in which relics of saints were kept. The **burial plate of Abbot Martin Feiden** († 1673) [16] also hangs in the northern transept arm. The deceased is represented with a portrait-like countenance. Among the group of burial slabs of secular figures is the **panel of Hartrad von Schönecken** [15], who died in 1351.

The famous **"Mattheiser Gnadenbild"** [22], a miraculous image of the Virgin Mary at St. Matthias, is kept in the chapel of the northern side-choir. Mary is shown in pregnancy. The baroque painting, probably from around 1700, displays iconic elements, as is suggested by its title, "Hagia Maria". On either side of the Marian image, there are panel paintings with scenes from the life of the Virgin Mother. These are works by *Willy Laros*, Trier, who created them from 1907–09 for the outer wing of a neo-Gothic altar, based on woodcuts by Albrecht Dürer.

The walls of the southern transept arm bear further burial monuments, such as the curved **plate of the Abbot Modestus Manheim**

▲ *"Mattheiser Gnadenbild", c. 1700*

(† 1758) [**19**] . The **organ** [**19**] was built in the organ-building workshop of *Karl Schuke*, Berlin, in 1977. Thirty-nine sounding organ stops are distributed among three manuals and one pedal.

In 1995/96, an image of the burning bush, based on a design by *Robert Köck*, was created for the window of the **sacramental chapel** of the southern side-choir. Also notable is an additional panel from the altar or choir screen of the fifth-century Cyrillus building. It serves a second function here as **antependium of the sacramental altar** [**21**].

Of particular interest in the nave are the two **altarpieces** [**7**] from around 1680, which stand in the second bay from the west. There are

alabaster figures positioned within the sandstone structures. On the right altar is St. Antonius the Hermit, on the left is the Virgin and Child with St. Anne. Both appear with assisting figures, including St. Benedict and St. Scholastica. The **burial altar for the imperial privy councilor von Rottenfeldt [10]** († 1665), which is from the now absent Maternus Chapel in the cemetery, stands in the west of the southern side-aisle. Two **reliefs** illustrate St. Peter's legendary emission of Trier's founding bishops, Eucharius, Valerius, and Maternus, and beside this, the reawakening of St. Maternus. Of particular interest among the furnishings are the four richly carved **Rococo confessionals**, crafted around 1770 by *Matthias Martin*, a master carpenter from Trier. One of them will be placed in the side aisle again, when its restoration is completed.

Various sculptures are individually positioned, whose original context of can no longer be established. The **crucifix [6]** on the gallery is generally dated to the middle of the fourteenth century. The head may be an addition. The standing Madonna with Child, the so-called **"Madonna of the Grapes" [8]** is of particularly high quality. Located on the fifth pillar on the southern side, it dates from around 1480. The wooden sculpture was created in a workshop in Trier, and its frame has been renewed. Also in wood, the **figure of St. Benedict [20]** on the southeastern pillar of the crossing was made around 1500 in a Swabian workshop.

Aside from the reliquary shrine of the apostle Matthias, the **crypt [12]** also houses the reconstructed altar or choir screen of the church of *Bishop Cyrillus* from the period around 450/455. The sarcophagi of St. Eucharius and St. Valerius stand in the western bay of the late medieval section, also with a choir screen. The partially original plates display shallow reliefs with scale-like patterns.

The furnishing of the basilica finally also includes the five-voiced **chimes** of the western tower, cast by the *Mabilon & Co* foundry, Saarburg, in 1965. The most important furnishing element is the famous **reliquary of the cross**, which can only be viewed by appointment (fig. p. 34/35). Around 1203/04, Sir *Heinrich von Ulmen* obtained large particles of the crucifix during the fourth crusade in Constantinople. In 1207, he donated portions of it to the St. Matthias Abbey, among

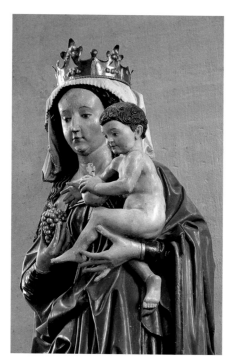

▲ *Madonna of the Grapes, c. 1480*

others places. In the form of a Greek cross, the relic is embedded in the front side of a wooden panel, which is beset with gilt silver and copper, enamel work, stones, and pearls. Two silver-cast and gilt angels kneel on the upper beam of the cross, swinging thuribles. In the middle of the outer frame, an onyx cameo above bears the portrait of Emperor Tiberius. A second ancient cameo depicting Zeus and Ganymede is affixed below. The reverse side is engraved with a representation of the *Maiestas Domini*: Christ is enthroned at the center, and circles holding the four symbols of the evangelists occupy the diagonals. The image is framed by arcades with saints and benefactors: Above is the

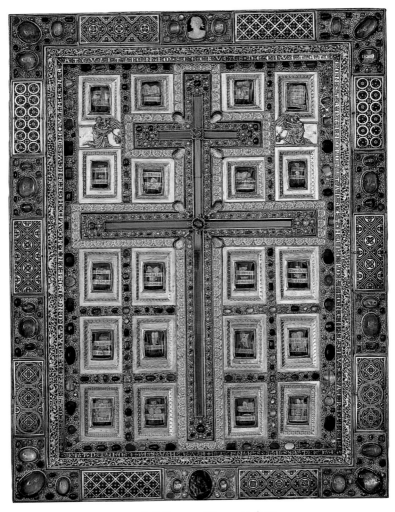

▲ Reliquary of the cross, front

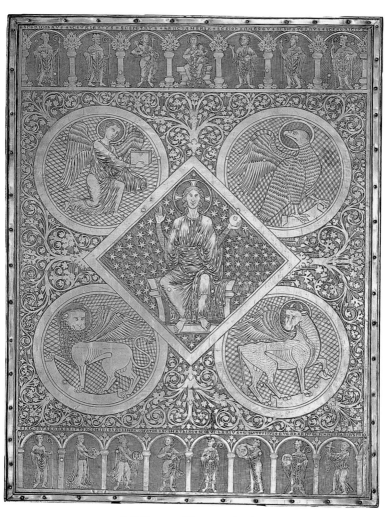

▲ *Reliquary of the cross, back*

enthroned Madonna with Child, surrounded by the apostle Peter (left) and John the Evangelist, a co-patron of the church, as well as saints. Below, the church's patron saints Matthias and Eucharius are flanked by benefactors (fig. on the back cover flap).

The St. Matthias work was dated around 1220/22, until it was recently estimated around 1243/46. Together with the Staurothek in Mettlach, among others, it belongs to a group of works of goldsmithery from Trier. Their technique is traced to the metallic arts of the Maas region. Corresponding motifs give evidence that the artists were also familiar with the Byzantine Staurothek of the Limburg Cathedral treasure, which the knight had also brought from Constantinople.

Cloister and Abbey

The **cloister** is located on the southern side of the church. Its former chapter house, refectory, and former dormitory date from the thirteenth century, while the **abbot's house** in the east is in the Late Gothic style, and the western wing took its baroque form under *Abbot Cyrillus Kersch*. Visits to the cloister are only possible in exceptional cases and only by appointment. An unusual characteristic of the structure is that, in relation to the other facilities, the entire square is shifted towards the east. Furthermore, the current cloister had a predecessor, whose remains, which date from the first half of the twelfth century, survive in the masonry of the connecting building between the choir and the northern wing.

The existing cloister, "one of the most precious Early Gothic works on German soil" (*Georg Dehio*), was erected in 1220/40. Construction began with the northern wing, of which only ruins survive today. Here, horn consoles with crocket capitals supported the vaults. The southern half of the western wing features ribbing with pointed-arch profile. A single-aisled summer refectory with ribbed vaults stood at the southern wing until it collapsed around 1400. This was also the location of a fountain hall that was built between 1519 and 1526, but has since disappeared. The eastern wing, the latest section from the thirteenth century, includes the two-aisled, oblong chapter house, which is used

Eastern wing of the cloister, c. 1220/40 ▶

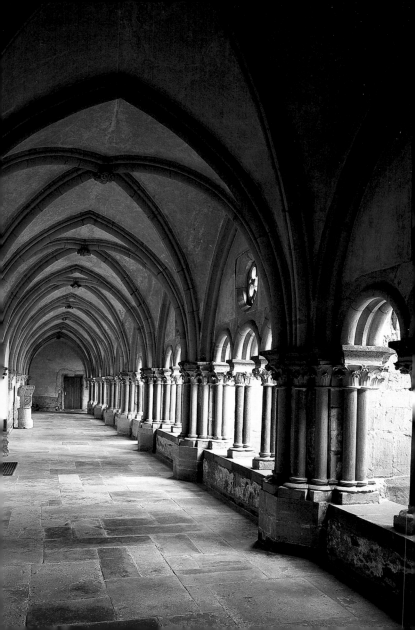

as a sacristy. Also located here, the refectory, with its five bays, was renovated in baroque style in 1730. The three-aisled dormitory above is used today as an oratory and library.

Chapels within the Abbey Walls

Various chapels stood on the cemetery. The **Chapel of Mary**, consecrated between 1242 and 1253, was built at the end of the cloister's construction. In 1809, the chapel was partially torn down, reduced to four compartments of the western choir. It was reconstructed in 1975 according to the original floor plan, for use as a chapel for the dead. The tracery of the original lancet courses is directly related to Trier's Church of Our Lady and is among the most significant examples of the Early Gothic style in Germany.

The **Quirinus Chapel**, a hexagonal centrally organized space, was consecrated in 1287. In 1637, larger windows were installed, the vaults were renewed, and the curved roof with lantern was added. *Abbot Martin Feiden* commissioned the portal, as can been seen from his coat of arms and the inscription of the year, 1664. The abovementioned **Albana Crypt** (fig. p. 41) lies beneath the chapel. It is a barrel-vaulted space with an apse. A Roman sarcophagus decorated with a relief stands in the center. The rich traces of the original color scheme are extremely rare: yellow, red, green, blue, and black. Portraits of a deceased woman and her husband are sculpted on the cover of the sarcophagus. Analysis of the reliefs and examination of the couple's remains have revealed that the sarcophagus was first used around the year 270 CE. It is likely that the deceased are the wealthy widow *Albana* and her husband. It was in their home that the first Christian community of Trier gathered together with Eucharius and Valerius.

Side Buildings around the Courtyard

The large **courtyard** west of the church is surrounded by various medieval and modern buildings. The visual impression of the space is marked by the modern fountain with its cross. Water gushes into the

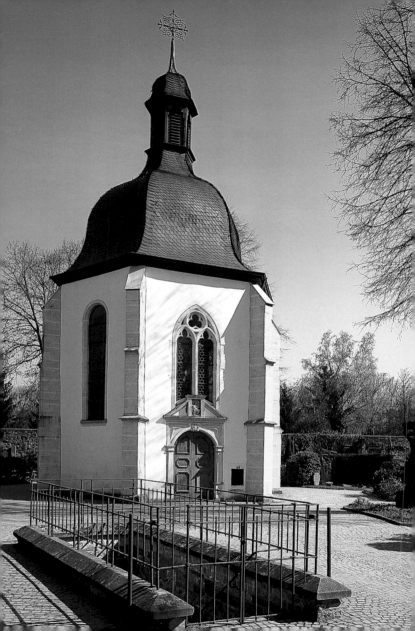

basin from the foot of the cross. The **"Pacelli Cross"** memorializes Eugenio Pacelli, the later Pope Pius XII, who was in Trier in 1927 as Nuntius. It was thanks to his decision in 1950 that the abbey's further existence was secured. For this reason, the coats of arms of the abbey (western side), Pope Pius XII (eastern side), the bishopric (southern side), and the city of Trier (northern side) are displayed on the capital. An inscription on the base names the two other great European graves of apostles (St. Peter in Rome, and St. James in Santiago de Compostela), and indicates their distances.

The former **pilgrims' hostel**, now used as a parsonage, stands at the northern side of the cemetery. It was erected by *Abbot Nikolaus Trinkeler* in the second quarter of the seventeenth century. Beside it are the abbey's medieval hospital and the Nicholas Chapel, which was first referred to in 1284. The buildings illustrated by *Lothary* in 1794 were torn down in 1807 (fig. p. 2). In 1922/23, remains of the buildings and of a school erected in 1878 were integrated into the existing plastered building, which initially served as a "transitional abbey". As a result, a figure of St. Benedict from the 1920s stands above the main entrance of the building, which is used today in part as a parish center.

The **gate house**, a hipped-roof building from 1717, rises at the western end of the courtyard. It is referred to as the courthouse ("Gerichtshaus"), since it was the seat of the abbey's upper and lower courts until 1802. Figures of the three elder patrons of the abbey, Eucharius, Valerius, and Maternus, stand in the dormer. Gateways on either side of the gatehouse – one dates from around 1700 – separate the enclosure from the street. The so-called **Fish House** (fig. p. 42) adjoins on the southern side. The eighteenth-century square building has a stone fish basin in its ground floor. The plastered building was transformed into a garden shed in 1830, and the upper floor was redesigned in early neo-Gothic Classicist style. The **abbey's guesthouse**, with a gateway and the abbey shop, stands on the southern end of the courtyard. It was designed as a counterpart to the structures facing it in 1957/92.

Relief sarcophagus in the so-called Albana Crypt ▶

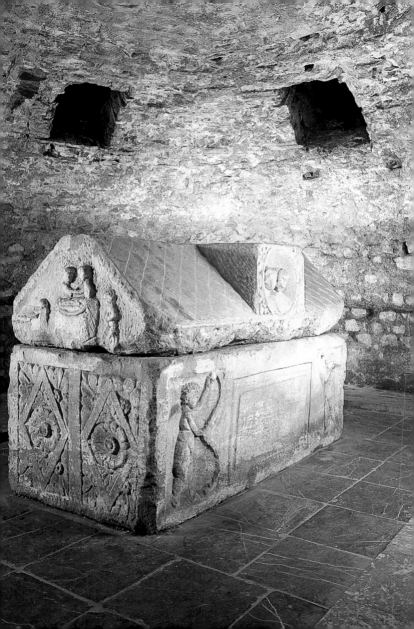

▲ *Fish House*

Literature

Bunjes, H. / Irsch, N. / Kutzbach, F. and others, *Die kirchlichen Denkmäler der Stadt Trier mit Ausnahme des Domes* (Die Kunstdenkmäler der Rheinprovinz XIII.3), (Düsseldorf, 1938). – Cüppers, H., 'Der bemalte Reliefsarkophag aus der Gruft unter der Quirinuskapelle auf dem Friedhof von St. Matthias', *Trierer Zeitschrift* 32/1969. – Kubach, H. E. / Verbeek, A., *Romanische Baukunst an Rhein und Maas*, 4 vols (Berlin, 1976–89). – Jakobsen, W. and others, *Vorromanischer Kirchenbau. Katalog der Denkmäler bis zum Anfang der Ottonen* (Supplemental volume), (Munich, 1991). – Becker, P., *Die Benediktinerabtei St. Eucharius-St. Matthias vor Trier*, Germania, Sacra NF 34, 8, (Berlin/New York 1996). – Clemens, L./Wilhelm OSB, J.C., 'Sankt Matthias und das südliche Gräberfeld', in Kuhnen, H.-P. (ed.): *Das römische Trier* (Guidebook for archeological landmarks in Germany), (Stuttgart, 2001). – Sebald, E., 'Überlegung zur Bau- und Restaurierungsgeschichte der Abtei- und Pfarrkirche St. Eucharius-St. Matthias in Trier', *Denkmalpflege in Rheinland-Pfalz* 52–56/1997–2001. – Seepe-Breitner, A., 'Untersuchungen in der Krypta der Abteikirche St. Matthias in Trier. Ein Arbeitsbericht', *Archiv für mittelrheinische Kirchengeschichte* 56/2004. – Weber, W., 'Archäologische Untersuchungen im Westteil der Krypta', *Archiv für mittelrheinische Kirchengeschichte* 57/2005.